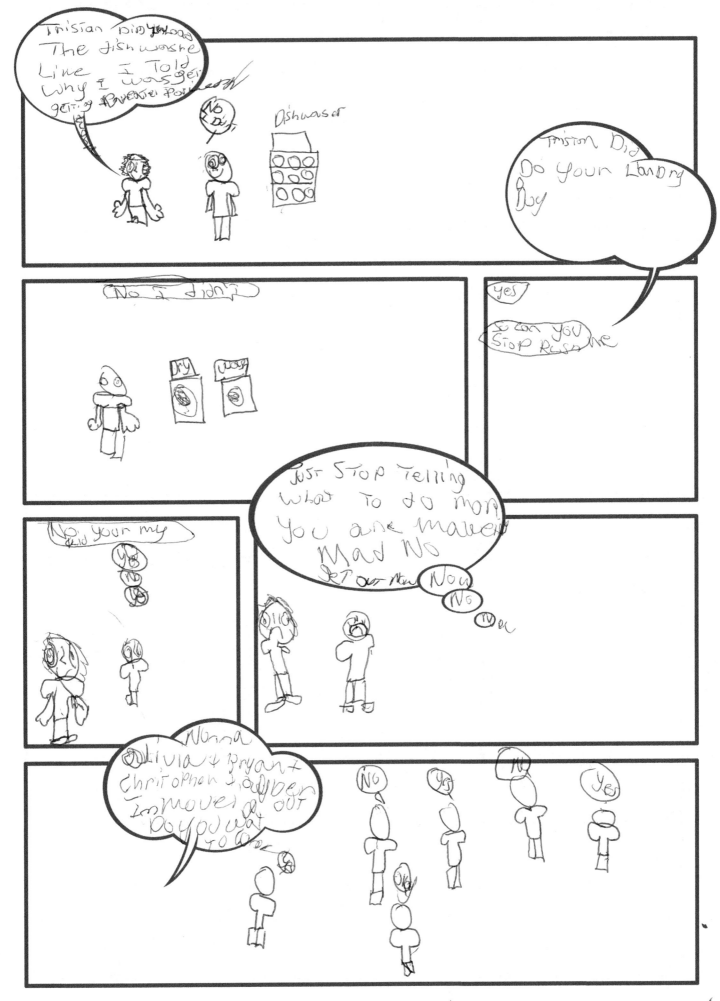

Bryan Did you Do your Mornig ROTUNE. No. Why Im Grown Im To Big To Have That Woman

One Day me and my crazy Brothers went to Sky Zone we fighting each oother The I fight them when I got worn Soft Ball I foul in water

No your Not you are 13 years old so I will give you One and you will DO IT... ...No Im Not Pleas Can I Not Do I This ween... oh Fine you will do I Next week Yes nanna said

So when we Jame Back Home IT was Dinner Time So we eat with The So we eating HamBergers and chiken and french Fries To For Dinner So I Say Lets start Have Fun so we Did Dinner

So we get To our Big House and went To sleep on the Couch

We So IT was Mornig Im going To Hang Out with Calvin An Hobbes, See you on 3 Min

Im at Calvin and Hobbes, Cravin Are Jumping App op wall all around The House So we Play And Calvin said let go Jump of The Roff He said yes so we Jump op Jump of the we said it was Fun Jumping Ap The Ramp and the Rope So

Lets NOT Try NOT To do IT again Bryan said

2

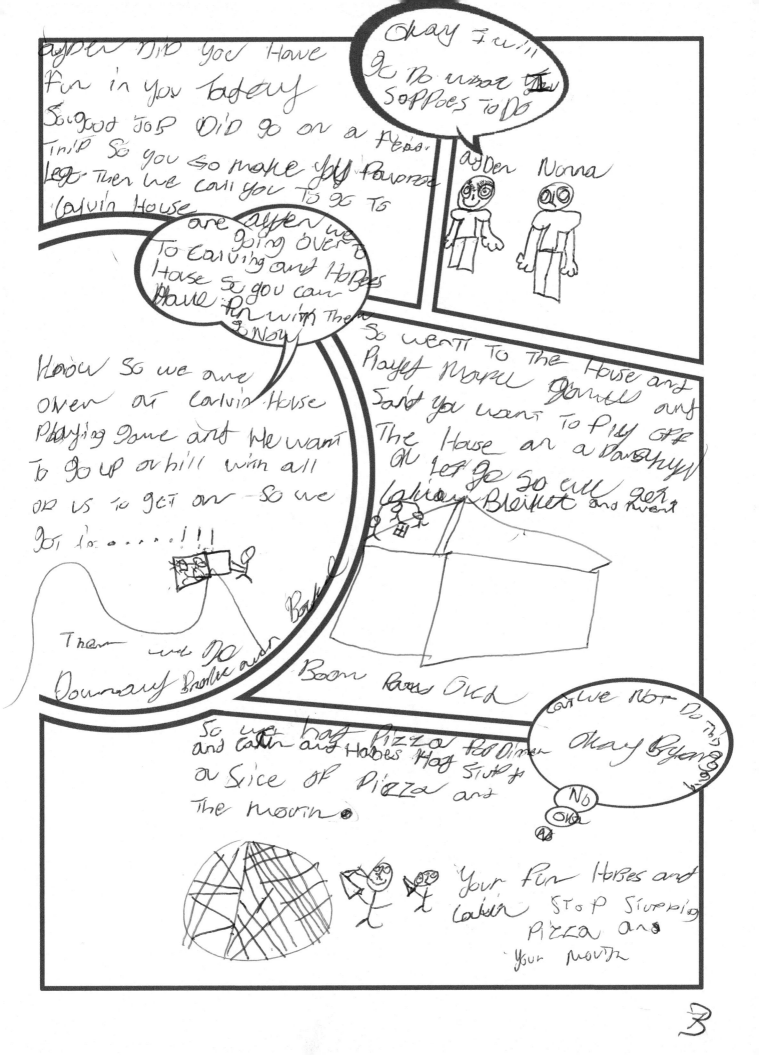

Chapter Two

One day Im at school and my teacher
I hand that you are a Publisher
said Mrs Tuller with yes Im made a Book
called Playing ~~little~~ westside. said Bryan

So I go home and my aut said how was
school she said good So how was work

It was good that time and
Hurry

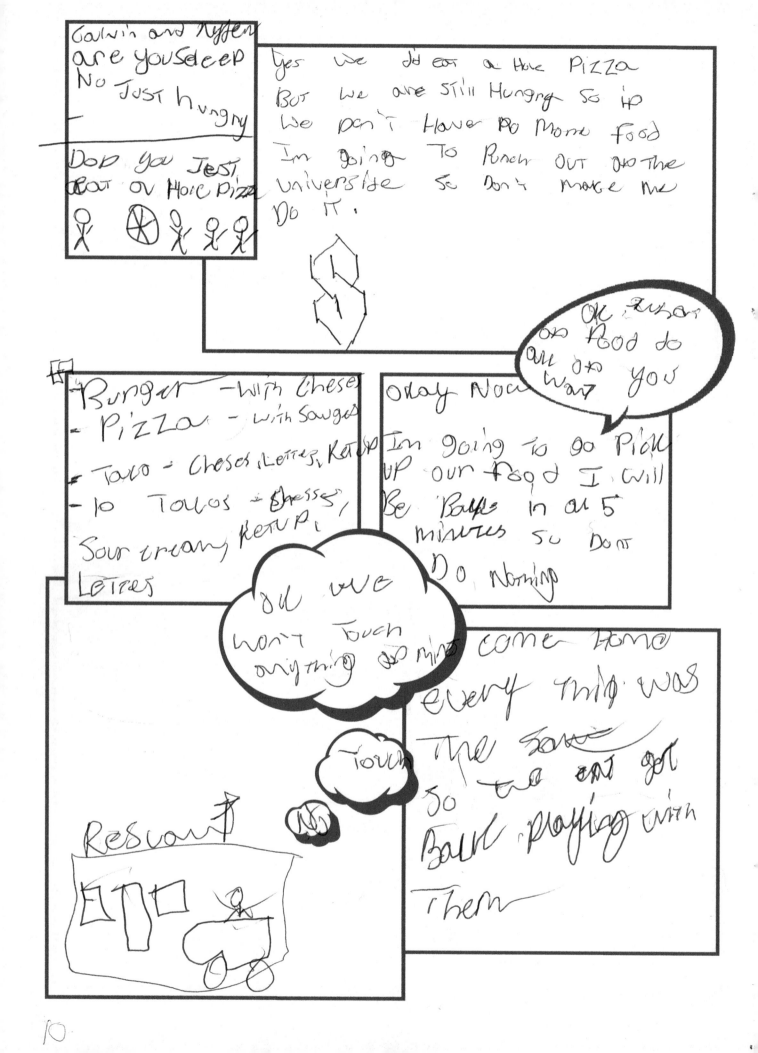

Then every
Body peel to sleep
then their parents
come home to a
clean anything wash
broken house.

11

13

18

18

19

20

HUH?!

CRUNCH!!!

BANG

OUCH

CRAAAAAAACCK

POW

VRROOOOM

CLANG

ZAM!

POW POW

BOOOOOOOOOM

ZWOSH!

ZAAAP

WHAP!

ZAAAAP

WHAM!!

Made in the USA
Monee, IL
29 November 2019